The Alchemist Cookbook

By: Omar King McCray

To My Son,
Bryce.
You
saved me
from myself.

The Alchemist Cookbook

Alchemist: a person who transforms or creates something through a seemingly magical process.

Alchemy is defined as the process of taking something ordinary and turning it into something extraordinary, sometimes in a way that cannot be explained.

1

"What is the world's greatest lie?"
the little boy asks.
The old man replies,
"It's this: that at a certain point in **our lives, we lose control** of what's happening to us, and our lives become controlled by fate. **That's the world's greatest lie."**

— Paulo Coelho, <u>The Alchemist</u>

2020

I've seen plenty,

Dark nights.

Bright mornings.

Heavy hearts,

We carry like burdens

Worry to an ulcer,

afraid of what's next.

I miss you, I love you...

Gone too soon.

I've seen plenty...

Ominous nights,

Hopeful mornings,

Broken **hearts,**

Stone walls,

Protected my wounds.

As clear as the vision of day.

But my **Hidden intuition,**

My mind's eye in hindsight...

Never foreseen such plentiful nights,

Nor did it warn me of the **mourning** to come...

<u>Untitled</u> **Generation**

The sad #generation with #happy pictures...

Captions meant to misguide you,

#Hashtags to brag about a #community that don't know you,

I'm lost in your #story,

I know you're #morningroutine,

coffee jet black,

one #Englishmuffin all at...4:15am.

I know #YOU better than I know #Me...

#Sadpictures,

don't make my timeline...

Not enough time on my line to care.

Generation

#unTitled.

<u>Alchemy</u> Freestyle

Don't know what's more horrid, my wallowing face or the thought of COVID.

In a time and space, love had no trace, from whence it came...

Freestyle your life and you are bound to make a profit.

Prophets profit off the logic of knowledge, so why go to college? Why? The **millennials wanna** know? What good is a **legacy,** when you're not around for the **encore** at the end of the show?... what's the purpose of life that never seems to live out its full potential...

George Floyd to King Von, they don't seem so coincidental. COVID makes us morbid, the country is full more shit, and now I can't even pay for a pot to piss in...

I wanna live in a world where the motto is **"enjoy the ride,** because there won't be another one."

Create magic out of tragedy...

the ultimate alchemy!

I. Am. Legend (Mr. Non-Photogenic)

I'm not **Mr. photogenic,**

Every **smile** you seen, was intended.

I guess that's why I'm not the first one they invite.

You know, that's quite all right.

My presence ain't **a present for everyone.**

Just coping, tryna raise my rapidly growing son.

In my demise, don't be surprise if they never mention me. It's ill how **the** realest never gets **an honorable mention.** Not to mention, **with ALL good intentions,** your intention was never to offend, SO WHAT DO we DO, we **pretend with** photos. All the worlds **artifacts,** they still find it hard to find Art-in Facts, fact is we **preach** with **less practice.** My Son will know, daddy was a legend **without the photograph,** without the highlights of social media. **He will hear echoes, echoes, of what daddy did,** he will see it all... **in ONE photograph.**

Make it home

My daily task is to make it home to you.

Never thought such, innate, sub-conscious duty of our lives... would be such a difficult

thing to do. **The cops stop** me, what do I do...? I hope this is just a misunderstanding,

I just wanna make it home and put **my son** to bed.

Yet, my execution will either be televised,

or a trending **#hashtag** instead, I

t will spark a movement that will be followed by **riots**, marches, people posting photos

they took with me,

followed by copy/pasted 6ft deep captions.

I'm a martyr **now**,

no longer I belong to my name,

I am a **martyr** that used to be a *father*,

who just wanted to make it **home**.

Fight

Thru our natural **born rights**,
We were wrong.
Thru our **god given** ability,
We were bound by Satan's inevitability.
Black vulner**ability**,
White fragility,
I still find it hard to fight,
Yet, I must with all my might.
Fight!

Bare Necessities

Hard to feed 8 wit 2 peas in a pot.
The ball, Pops dropped it a lot.
Yet, **hungry nights** We barely knew.
when the ODDs were stacked up against Us We still made it Even. Americas
Arithmetic, full of tricks, it **ADDs up** the lies and **SUBTRACTs the human fact** that
survival is imminent in the world we call the ghetto. My Home, how could I leave it
alone.
I remember, my Stomach tied in Pratt knots, twisted plots, no Smiles wasted **on these
mean streets. It's called survival,** where your **idols become your rivals,** your enemies are
the friendliest, where the mind up is for ransom, in the depths of the JUNGLE, **the**

BOOK holds no **value** and those are just the Bare necessities... **for survival.**

Insurrection

The **Evil** media would rather **turn racism into a necessary evil**,
rather than a **necessity** to eradicate,
They would rather **profit** off black **tears**,
Televise the abstruseness of **hate**.
 They would rather show **black mother**'s crying over **young** black bodies **dying** in the
street.
They would rather profit off my mommas tear ducts, than defund the police,
they would rather **grin on CNN** while talking about our democracy,
the hypocrisy...
Insurrection in progression.

The Root

We share the same pain,
same glory,
not the same story.
The root of America runs **deep** in our veins,
they taint
and taunt
the truth,
only to **disregard** our remains...
the rain that blossoms
the tulips and daisies
that grow
in the same world,
where we can be denied because of our BLACKNESS.
MY NAME AINT KUNTA,
I OWN MY MASTERS.
... same can be said bout the **blood** that was **shed**,
The root of it all,
flows within your veins...

2

"**Your** eyes show the **strength** of your soul."
The Alchemist

Daddy's Heart

Let them know **you are NOT defined** by your Melanin,
for **you are so much more.**
Yea, you may have **mommy**'s skin,
but you have your **daddy**'s' heart,
Never let them break you,
never let them see you fall apart.
Don't give em the satisfaction sun,
remember this,
to be A Black Man in America,
it means,
to be a broken one.
We Break for no one!
You got yo daddy's heart

Momma

I saw mommas' heart then,
I saw it when we would venture off to her appointments...
"Stay put like a good boy"
Here's your new toy.
So coy, I was.
Momma had a heart back then,
back when horrific memories tore a hole in mommas' soul.
Momma 'hold my hand,
While letting go of your pain.
We all have cried with Mother nature,
I cried with momma.
The night you lost your momma,
Felt like I lost my mine too.
Mommas' pain...
Is Mommas heart.
Just hope it finds you,
Momma.

<u>We all</u> have a **War**

We all have wars beyond these walls,
We **have** flaws **that** some may not see.
We all strive, but the **prize**, stay alive.
We have wars, we all have scars, some **we wear**,
where all can see, others remain dormant.

We all **share** fears and pains so **deep,**
it sleeps and rests its head on our cerebellum,
we All **Have** war stories,
don't be afraid to tell em!
We are all soldier's,
facing the moment of truth,
FIGHT your battle,
till your battle's won.
We are all in a **war...**

No Fucking Love (NFL)

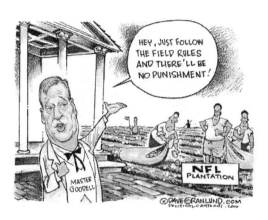

And I know I'm not the only one.
You see, I stay awake to hide from my
dreams and nightmares, seems to be
the only way I can protect you...
I check on you **often**, to **make sure**
you're still breathing.
Knowing **that very breath** you take, is
taken away from us, the irony. **Now** I
don't need to Walk the poetic bayou
wit muse Maya Angelou to **know why**
the cage bird sings. **Black People**, we
are that caged bird.
"I **can't breathe**...I. can't breathe...I can't breathe", or how about... "I'm sorry" ... Being
Compliant is non-

reliant,
But **I'm** just as **scared** as you **officer**,
"I just wanna get **home** too!
I wanna kiss my mom, I wanna **hug my dad.**" Sit at the table and discuss the day we had.
I don't wanna call **9-1-1**, I wanna **raise my sun.** You say, to serve and protect, but quick
to forget the very **laws you neglect**, while your knees on our neck.... now **where's the**
respect?
We tired of fighting, we tired of fussing, for your billion-dollar amenities, **fuck** your
anthem NFL, could of made Hov commish...Naw, you had **your** one chance to do right
by us and you give us this... it's more than a song Goodell, Shawn Carter ain't tell you
that? you just want slaves on Sundays, Now, LIFT EVERY VOICE FOR THAT, your
stadiums ain't nothing but **multi-million dollar plantations** anyways. **You fooled the**
nation, you thought by giving Kaep- Nicks, we wouldn't see your tricks!
Black folk still wit that crabs in a barrel complex,
fighting for likes, you should be fighting for your
rights! gangs claiming sets on govt recs. **Black on black**
crime on gentrified blocks named after **Malcolm** and
Garvey, To House Negroes trying to start beef! quick
to forget the names of the **slain** like Steve Harvey.

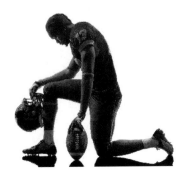

The **worse war to fight, is a war against the mind**, let's try to be patient, find some peace of mind, I know it's a hard find, in these trying, strenuous times. But Black on Black crime is like the blind leading the blind, **we WANT social justice**, we WANT our lives to matter, but **we're killing each other** to the benefit of our **oppressor**. Nina Simone once said "It's an artist's duty to reflect the times in which we live." Understand, this movement is more than a #Hashtag. Stop comparing MASTERS, you can stimulate us with checks, but you can't... **ARREST THE OFFICERS THAT MURDERED Breonna Taylor!**

Dr. Sebi and Nipsey

Them: white male reported to prison
Black male: arrested or **gunned down.**
Fear,
Comfort
Why do you think people find comfort in these fears?
You tell US, we sick, yet you push your deity, **convincing** me, there is no one higher than your white messiah. **Sebi** gave us the **cure** for AIDS, yet, you want us to live in the image of **Magic** Johnson. Such **simpletons**, why does it take years for **Black Men** to get off Ritalin, here's a riddle then,
how do you keep a Black Man from forward progression, teach em less, teach em how to suppress their emotions, never teach em how to channel their aggression, **anger suppression,** but you send em to **jail**, to teach em a **lesson**? Nip wanted to spread the butter of knowledge, learning BLACK self-worth, our philanthropic superhero, but sometimes a Black Superhero isn't what **BLACK AMERICA** is used to, let alone allow them to feed us knowledge without questioning, why isn't this coming from a white man? **No** more **degrees**, no more lies buried in the white sand. no more how to learn a trade.
Any takers, **fools'** wagers?

Did it pinch a nerve, did it light a bulb?
I'll tell you...

you have to... **(Gunshot)**
and that's all it was...

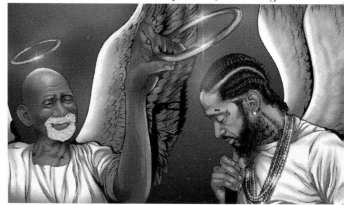

3

"**Everyone** seems to have a **clear idea** of how other people should **lead** their lives, but none about his or her own."

The Alchemist

Karen.

Karen, Karen, Karen...you see those patrols cars flashing from a distance. Sirens, Police Cars, I count at least four. Knees to the floor, both hands behind your back, eyes are closed as I recite a black boy's prayer "As I kneel down on this floor, I hope to see my home once more" 5 **White cops**, one white lady cop and Karen point their guns at me... and for what? Your gonna stick it to this "blackie now! Karen, with no Care in the world. You got your privilege right? Your confederate rights... There Goes that **privilege** again Karen, music blaring, people staring, theirs Karen, staring, preparing for that one phone call... (911 what's your **emergency**)

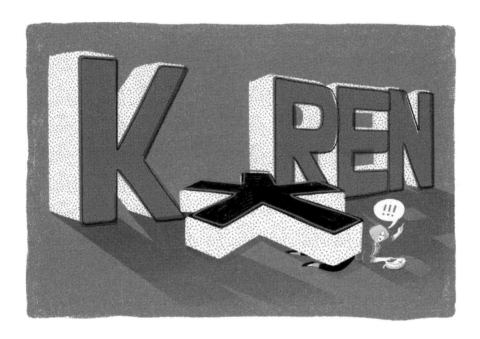

We get it, you fear us, we are more so in **fear** of how you'd react to our melanin but then again, we know the end result, we keep the hand were dealt. Instead of knowledge for you, I'm thinking knowledge for self. Karen, what you gon do when the police come thru? I read **Willie Lynchism**, I KNOW what they'll do, do you? Yea you do. Karen starts to lift her trigger finger, face is pale, forehead overflowed with sweat and possible regret... yet that regret you may feel, it's real, hold on to it, like my ancestors tried to balance holding onto their families, their pride, their dignity, their stomachs as it ached in the still of the night on those overcrowded slave ships, so yea, my people know about balance all too well. Karen, you feel that, your life is being threatened, I can relate to such ominous feeling growing by the second, surfacing every minute, sets as a reminder every hour, that I am just nigger. My New Era cap to the back, my culturally influenced vernacular must be a bother to you Karen. I don't know whose worse "Becky wit tha good hair" or the "paranoid Karen" who points her gun at us while we stand peacefully on lawns, or what about the KAREN who calls the police when we are just having a good OL TIME AMONGST OTHER BLACK FOLK, yet you point your guns at us...Karen, if you only knew your history. BLAMMMMM!

Make Amends

How do I **make amends** with friends that wanted the worse for me?
cause it brought out the best in them...
Contradictory hymns from fake friends,
Daps ain't the same,
your **passive aggression** over every status and quote,
Mr/Mrs everywhere, but never here,
when I need you.
Ah, your reputation precedes you **my friend**,
my former kin, my former "remember way back when", now, I can't even send you a
like, write you a note, send you a quote,
We were Cochise and Preach, but you would rather **preach what you didn't practice.**
What I realized is,
friendship is more about survival,
so many seasons to weather,
whether we were prepared for such climate...
mountains of issues we neglected,
We were supposed **to climb it.**
Although it's highly unlikely, we'd ever make **amends, like the African hymn goes,**
"Many may Grow, Few Grows Up!"
Fuck Friends!

Diallo interlude

My **Hometown**, I Dream...
In A Metaphoric **Dystopian, ruled by Ethiopians**, world spins backwards on its axis and
now we have an ass to kiss, pure bliss, first that, now this... Lately My **Black Folk**, you've
been disappointin' me, y'all rather act like Denzel in training day than Denzel as Dr.
Davenport. Now have that for sport, forgetting everything you were
taught, mannnnnn you nothing but a....

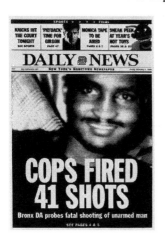

Nigger, Negro, Colored, Uncle Tom, Nigga.
Go figure, came full circle, no surprise, we came back to
the
word
Nigger.
Niggas, dying in the street,.
Niggaz, getting killed by the badge and the **Bandana.**
My hometown ain't been my hometown
Since Amadou was **gunned down.**

Black Girl/boy

You ain't no toy black **GIRL'**
No need to be coy.
Black Boy, you are more than a
IEP.
You see Black CHILD, you

Represent a **legacy**,
bigger than any degree.
Black BOY, soon to be Black **Man**...

You will weather all storms,
challenge all norms...
for our
Black Women,
let them know...
you'll rule the world.

Dear U.S.A

America EAT its babies **served** with **propaganda entrees**...The question I ask is,
Why do we give such **attention** to **pretentious** folk **America**?
I find **comfort**, that bedtime, tummy full of **soul food** comfort in knowing you can't
replace me...America.
I feel **serenity** when you **tempt me** to submit America...
I Wonder...
If the memories of **slaves died** today, I wonder what
food you'll eat **America**, who would you have clean
your floors America? **become your whore**s?
America, you got some **explain**ing to do... Knowing
damn **well**, black folks **love us** some pie...
So, I ask...do you blame the baker or the naive
consumer? **I hear** your whispers in the **wind, I see**
you would rather hide in the shadows of **lies** and
your timid **bigotry,**
America
I wonder...
would **you still feast** on US?
America...
you got some **explain**ing to do...

Just Us

Too many times **crimes** go unjustified...
Too many times we were told to just **cope,**
One thing about hope is... it's **relentless.**
But! There is no more **hope...**
Living in a world where if we **kneel,** there's a chance we won't get a deal.
Living in a world where **Eric Gardner** could be **my father,**
My **Nephews dies as Martyrs...**
Don't go-fund me my funeral, go **find me justice...**
Cause right now I feel like it's **JUST US.**
I see through the eyes of the **law,** flaw after flaw...healthy
confrontations we avoid, same reasons why Kaepernick
remains **unemployed...**
Wanna fill a **void,**
Kill the **noise...**
Justice for US.

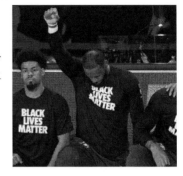

<u>4</u>

"No matter what he does, **every person** on earth **plays a** central **role** in the history of the world. And normally he **doesn't know it.**"

The Alchemist

Black teacher

Teach me
Black teacher,
Preach to me...
That **African gospel.**
Be the spokesperson for
All **black** folk'
Teacher, teacher...
What type a BLACK teacher **you** is?
Are you the type to talk to em,
as an **equal**...
not lesser than.
In my class, my students have a **voice.**
They are **empower**ed with choice.
I'm the Black teacher that pushes **confidence!**
Black **prominence!**
We can't scream **Black Excellence**, if we haven't designed the metric of what excellence is!
My kids are **not an experiment,**
They are **so much more,**
I won't belittle their minds for a state score!
So, no, **I won'**t let **the**m settle in this **race!**
In a **world** where second place is **Black victory!**
And YES! I will disregard your 2min knock,
During my parent teacher conference, because at some point our parents need to know, it's more than just a conference, it's a conversation! A **time** limit that I will gladly go over, as long as that child walks out more em**power**ed than they walked in. You see, we can't **nurture** them if we fail to comprehend their **nature.**
I'm more than black teacher, I'm a black father, never one to bit his tongue or hold out a swear! **Be prepared** to be pushed by this **black teacher**, until the very last breath of gratification, even when that's too much to bare, we will go further! **That's called earning,** and that's only lesson one!
I'm the black teacher who...
Inspires YOU.

The Recipe

Even with the proper **ingredients**,

We still **had a bland mixture.**

Quite the elixir, my eyes were **fixated on your brown sugar**, two DD cups of **vanilla** extract **made me relapse and** perhaps this may be her first **taste**...

She pleaded for **the recipe,**

She took the best of **me**, even the lesser me.

There were times when I had to

Self-exam myself,

all the while that was YOU testing me.

I sample the sauce of course, the taste is impeccable, the scent is from **heaven.** Reminder of why my favorite number is seven.

I cook for two now,

I cook for you now...

Using My Recipe.

Things Fall Apart

I was a **mess** when you **would leave,**
I would **grieve,**
and grieve some **more**...
I was in **lust for your flesh,**
never cared about the **rest**...
but that **was when I fell apart.**

Broken promises led to breakdowns.
Broken-hearted, led to broken spirits.
At the core of your brokenness,
there is a **revival,**
a **rebirth.**
You see the **pieces on the floor,**
you **pick up what you can,**
you make **amend**s with **your ego,**
reason with **your heart**....
Such irony, such euphoric epiphany's...
I crave the symbolic symphonies
that resonate with my **sky that has** fallen.
But, oh the beauty living in a world of the **fallen,**
you see the pieces for what they are...
and realize things indeed fall apart.

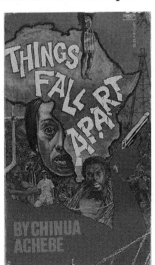

And I know this much is true...

And I know this much is **True**,
I love you, and you love me too,
Right?
You see me,
you understand... me.
And I know this much is true,
You love me,
you really fucking love me.
We grew, you knew,
You knew me before I even had an idea of myself.
You turned my love into You...
I breathe you,
Like a San Fernando Valley strain.
Here I stand, a man.
I take a deep breath,
YOU touch every fiber of my soul...
I no longer have control,
Love is like this...
Just as the Sky is Blue...
Love is You...

I know this much is true.

BronxHero
I **never** want to **be revered**...
Such **accolades** never reflect the **true meaning** of a being.

I never wanted my name in the bright lights...
You're **vilified** before you're **exonerated.**
my words and truth illuminated
This **dark globe.**
The more you know,
the more you grow,
theories make headlines,
your truth is what they line up in chalk.
Streams of tears fall,
thru these years,
months slow down,
weeks fall between the cracks,
days compensate where the hour lack...
and seconds we can never retract.
Yet my name remains in the bright lights,
My accolades spread through the world wide **web of confusion.**
And it seems the more I thought I knew...
the more I realized I knew nothing at all.
BronxHero, the **inevitable fall.**

"Social Dilemma"

Social media makes up what you can't fix.
Hiding behind insta flashes,
faded eye lashes,
All the while...
The world laughs at you.
Yet, your social codependency,
We exist in, we shun our kin for,
To get closer to him...
His friend, his kin... so immersed in outer worlds, you forget ya own.
What's yo status in this matrix apparatus we call...
Facebook, let's look...
they care less bout how a face look
and more bout how you can save face,
look we care less bout each other and more about a trend, we fake it till we make it
cause it's the best way to pretend.
Add a friend

The TALK with My Son...

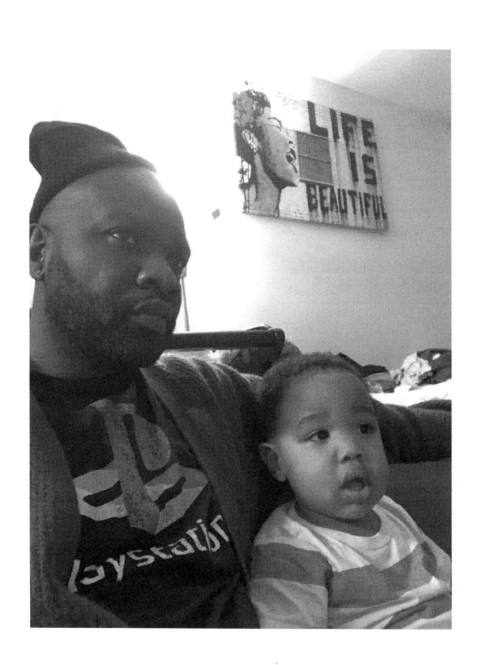

If I were to have a conversation with my son, here's how it would go, I'd share all of my secrets, tell em all that he should know, I'd tell him to sit up straight, look a man dead in the eye, always tell the truth, life will hurt you more when you lie. He'll then ask "why all the people who are considered "bad" all look like me? I'd give a slight chuckle, and tell em our pigmentation, forced gentrification, a history almost 400 years in the making. Rights implanted in this world, were not written with us in mind. We live in a world where, if stopped by cops, if we comply, we still die... I proceed to wipe dawdling running tears coming down my sons left cheek, at that moment I realized, I can't protect em the way a black father should..., Son, life will get hard, on god, I swear, but life will get easier, the more you prepare. I may not get to witness your hearts passion with you, but just know that the spirit is way more influential than the physical... opportunities, yea I miss those knocks...your dad never had the time, your dad lost those clocks, to whom much is given, much is expected, never neglect your grass son, "what about friends?" My son asks...Yeah, your dad had some, I guess our bond never stood the test of time... if you remember nothing, remember this, "A Loss Ain't always a Loss, it's A hidden Blessing behind it". People will find happiness in your sadness...find triumph in your defeat. It is only in the time of their misery, they will then notice your empty seat... I give you these life jewels so you can wear with any shoes you choose, just make sure they're the perfect pair... take shit from no one, let success be your gun. You'll see the ugly in the beautiful ones. You'll know when it's right, your heart will let you know. I hope you understand that this world is cold, it will chew you up like a southern fried liver, and spit you out like tobacco...time, you can never get back tho, just know, life ain't got a back door' face everything head on, see the true colors of life without fluorescent lights... BUT be prepared for the turbulence. One day, the words I say will all make sense...

Alchemy.

IF THIS WERE AN **ALBUM**, I ASSUME THE FOLLOWING
WOULD BE CONSIDERED **BONUS TRACKS*****

"Mary"
(The first short story I ever wrote)

Many nights I grew an anxiety attack, a sharp pain that traveled from my heart to my back. The unsympathetic chills gave me the discomfort of a presence I have never ever experienced before. My pillow that once was occupied by the angelic face of my Mary is now flat from the many nights I consoled and held it tight as if it were. Alone in my bed tossing and turning wishing I were dead. Just a couple of days ago, Mary was in our kitchen cooking up some of her finest Monday cuisine. She always felt as though to get me to do something, she had to cook for me, it worked 90 percent of the time, well, ok all the time.

Mary wanted me to accompany her to best friend Angela's baby shower, I mean what guy you know goes to a baby shower, let alone sacrifices football Sunday. I gave in once I saw her puppy dog eyes, like the ones you see in those cute little puppy calendars they sell in target by the impulsive item's sections under the candy. As she was preparing the lasagna, which was another reason why I gave in so easy to the invitation to "googley" eyes and baby blue coloring that will soon surround me. I hear "papi can you run to the store and get some parmesan cheese for the lasagna." I was in no mood to get up off the couch, the New York Giants were playing, and they gave up a 27-3 lead to the damn Chicago Bears can you believe that. "Babe give me a minute", I reply, she mumbles something unpleasant. Growing impatient she slams the bottle of olive oil on the kitchen counter. "If you didn't want to go, all you had to say was Mary can you go please". I sense the sarcasm so I built on it, "Mary can you go please".

That didn't work well in my favor. I sense she was pissed because she hates my sarcasm but her attitude with me did not faze me one bit, I grew uninterested as I watched the Giants continuously disappoint me. As she put on her red and black north face snorkel that she had since high school, Mary says irritably "do you want or need anything else from the store", "NO" I replied. Not realizing how lurid I sounded when I said that, before I could correct it, she stormed out the house. Slumped down on the couch in my lethargic slumber, a commercial came on about the re-releasing of *The Shining* by Stephen King on DVD.

As I watched the commercial, I remembered how much I laughed whenever I heard the little boy in movie say, "red rum"," red rum". All alone I started to think about how Mary and I met. We were what them deem as high school sweethearts. We were as Mary would call it, "soulmates"; I never wondered how my life would be without her. She would randomly asks me on days I'd never expect such line of questions, on lines in supermarkets, walking home from her mother's house on Sundays after church. She would ask me how would our lives be if we never met or if something happen to her? I never once gave an answer, to cavalier to proclaim that I would be lost without her, if she were to ever leave my side, I refrained from ever conveying such emasculated emotion. As I grew thinking of how I sometimes take Mary for granted, I started to wonder what in the world is taking her so long. As any concerned boyfriend would, I went out searching for her.

I began to contemplate where could she be, she was never the one to stay outside, we rarely stayed around here, it wasn't the safest of neighborhoods. Just last week Mrs. Pickett was robbed at gun point thank God she was alive to be able to tell that story. I started to ask dudes at the corner store I normally ran into when I would go to the corner store; they said they haven't seen Mary. Those answers grew repetitive and I grew fearful and weary. Until a corner I second guessed to turn, I walked into. My greatest fear became my reality. My Mary lied there, helplessly on the ground. I saw the parmesan cheese on the ground and blood on her coat; I remembered my heart stopping and body feeling frozen. My life flashed before my eyes as if I were dying, but deep down I am dying. My soul mate, my Mary was no longer with me. Now as I lie here on this cold month of December, I spend my days wondering the questions she would always ask me and never had the answers to.

1730

(The Hidden Track)

Mommas callous ridden **hands** rub together while she sat at the kitchen table.
No cable,
no stable income,
Pops sold **hope** like **dope to us.**
Parents made do with rent due,
Who knew, my love grew for you like...
One and One is two... add one that's me, you see, **I** never thought **I was enough**...
Always lived in the shadow of big Sis. Picking fights, I knew I'd lose,
love grew then,
even at a time when I lost all respect for you...
all I ever wanted was to be able to stand **next to you**...

COVID-19

March 13th 2020,
The day will live in great infamy,
That's when I knew you had it in for me.
At least send an email, but you and I both know, I don't check those too well.
Not a minute to process, not even a day or two...we all felt it in our lungs, soon the
world would inhale it too...
lost of smell,
Sense of taste,
Let's not forget the red hot
Fever,
If that didn't make you a believer,
We lost one PLUS MORE!
To all those who lost more than they can imagine.
Tragic symphony...

Write

Son,
I write my wrongs so you can live righteous.
write to make it right son,
write your wrongs son!
In the long run, son...
you will understand the **for**ce of man,
the longevity of a lie is a short span.
Write your **pain,**
sing your sorrow,
strum your scars
till they're nothing left,
 just **your body's memoirs.**
Write.

Thanos

Your smile devours all that is privileged,
to catch a glimpse...
Happiness was never solely yours to keep.
All the while...
I hope to one day see you smile again,
That infinite grin...
You see me,
Yet my heart is as see thru as an old NYC token...
Open as such too,
without you,
I am left with contrition...

You were my inevitable ambition.

KING OF LOVE
February 14th.2021

KING OF LOVE
February 14th.2021

Made in the USA
Middletown, DE
12 February 2021